VAGINAWARRIORS

essay by EVE ENSLER photographs by JOYCE TENNESON

BULFINCH PRESS

NEW YORK BOSTON

V-DAY is a global movement that helps antiviolence organizations throughout the world continue and expand their core work on the ground while drawing public attention to the larger fight to stop worldwide violence, including rape, battery, incest, female genital mutilation, and sexual slavery. V-Day exists for no other reason than to stop violence against women. In just six years, it has raised over $25 million and was named one of WORTH magazine's "100 Best Charities." V-Day stages large-scale benefits and promotes innovative gatherings and programs. More than five thousand V-Day benefit events—produced by local volunteer activists and performed in theaters, community centers, and houses of worship and on college campuses—have taken place around the world, educating millions of people about the reality of violence against women. The official V-Day Web site is www.vday.org.

Eve Ensler's proceeds from the sale of VAGINA WARRIORS will benefit V-Day.

Bulfinch Press

Time Warner Book Group
1271 Avenue of the Americas, New York, NY 10020
Visit our Web site at www.bulfinchpress.com

First Edition

Library of Congress Cataloging-in-Publication Data
Ensler, Eve.
Vagina warriors / essay by Eve Ensler ; photographs by
Joyce Tenneson. — 1st ed.
p. cm.
ISBN 0-8212-6183-5 (hc) / ISBN 0-8212-6184-3 (pb)
1. Women — Violence against — Prevention — Case studies.
2. Sex discrimination against women — Prevention — Case studies.
3. Social advocacy — Case studies. 4. Women volunteers in social service —
Pictorial works. 5. Women human rights workers — Pictorial works.
6. Feminists — Pictorial works. 7. Photography of women.
I. Tenneson, Joyce. II. Title.
HQ1233.E67 2004
362.88'082 — dc22 2004009883

Creative Direction and Design by Michael Goesele

PRINTED IN ITALY

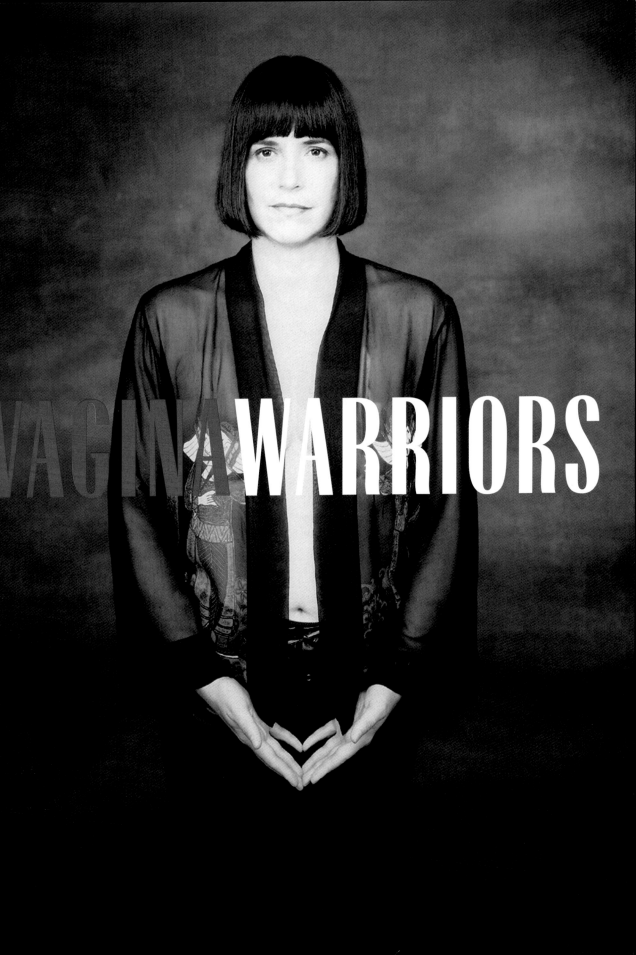

Vagina Warriors: An Emerging Paradigm, An Emerging Species

Eve Ensler

I have sat with women in crowded factories in Juárez, in crumbling shelters in the back streets of Cairo, in makeshift centers for teenage girls and women in Jerusalem, Johannesburg, Pine Ridge, and Watts, in mansions in Hollywood, in burned-out backyards in Kosovo and Kabul, in a moving van after midnight with sex-trafficked girls in Paris. Sometimes these meetings went on for hours; in the case of the seventeen-year-old Bulgarian sex slave, we had thirty-five minutes before her pimp came looking for her. I have heard the staggering stories of violence — war rapes, gang rapes, date rapes, licensed rapes, family rapes. I have seen firsthand the scars of brutality — black eyes, cigarette burns on arms and legs, a melted face, bruises, slices, and broken bones. I have witnessed women living without what is fundamental — sky, sun, roof, food, parents, a clitoris, freedom. I have been there when skulls washed up on riverbanks and naked mutilated female bodies were discovered in ditches. I have seen the worst. The worst lives in my body. But in every case I was escorted, transformed, and transported by a guide, a visionary, an activist, an outrageous fighter and dreamer. I have come to know these women (and sometimes men) as Vagina Warriors.

It was Zoya who first took me to the muddy Afghan camps in Pakistan; Rada who translated the stories of women refugees as we traveled through war-torn Bosnia; Megan who led pro-vagina cheers on a freezing cold campus in Michigan; Igo who made jokes about land mines as we sped in her jeep through the postwar roads outside Pristina, Kosova; Esther who took me to the graves marked with pink crosses in Juárez, Mexico; Agnes who walked me up the path with dancing and singing Masai girls dressed in red, celebrating the opening of the first V-Day Safe House for girls fleeing female genital mutilation (FGM).

At first I thought this was just a rare group of individuals, specific women who had been violated or witnessed so much suffering they had no choice but to act. But after five years of traveling, forty countries later, I've seen a pattern emerge, an evolving species. Vagina Warriors are everywhere. In a time of escalating and explosive violence on the planet, these Warriors are fostering a new paradigm.

Although Vagina Warriors are always original, they possess some general defining characteristics:

- They are fierce, obsessed, can't be stopped, driven.
- They are no longer beholden to social customs or inhibited by taboos.
- They are not afraid to be alone, not afraid to be ridiculed or attacked. They are often willing to face anything for the safety and freedom of others.
- They love to dance.
- They are directed by vision, not ruled by ideology.
- They are citizens of the world. They cherish humanity over nationhood.
- They have a wicked sense of humor. A Palestinian activist told jokes to an Israeli soldier who pointed a machine gun at her as she tried to pass the checkpoints. She literally disarmed him with her humor.
- Vagina Warriors know that compassion is the deepest form of memory.
- They know that punishment does not make abusive people behave better. They know that it is more important to provide a space where the best can emerge than to "teach people a lesson." I met an extraordinary activist in San Francisco, a former prostitute who had been abused as a child. Working with the correctional system, she devised a therapeutic workshop where convicted pimps and johns could confront their loneliness, insecurity, and sorrow.

• Vagina Warriors are done being victims. They know no one is coming to rescue them. They would not want to be rescued.

• They have experienced their rage, depression, and desire for revenge, and they have transformed them through grieving and service. They have confronted the depth of their darkness. They live in their bodies.

• They are community makers. They bring everyone in.

• Vagina Warriors possess a keen ability to live with ambiguity. They can hold two existing, opposite thoughts at the same time. I first recognized this quality during the Bosnian war. I was interviewing a Muslim woman activist in a refugee camp whose husband had been decapitated by a Serb. I asked her if she hated Serbs. She looked at me as if I were crazy. "No, no, I do not hate Serbs," she said. "If I were to hate Serbs, then the Serbs would have won."

• Vagina Warriors know that the process of healing from violence is long and happens in stages. They give what they need the most, and by giving this they heal and activate the wounded part inside.

• Many Vagina Warriors work primarily on a grassroots level. Because what is done to women is often done in isolation and remains unreported, Vagina Warriors work to make the invisible seen. Mary in Chicago fights for the rights of women of color protecting them from neglect and abuse; Nighat risked stoning and public shaming in Pakistan by producing The Vagina Monologues in Islamabad so that the stories and passions of women would not go unheard; Esther insists that the hundreds of disappeared girls in Juárez be honored and not forgotten.

• For native peoples, a warrior is one whose basic responsibility is to protect and preserve life. The struggle to end violence on this planet is a battle—emotional, intellectual, spiritual, physical. It requires every bit of our strength, our courage, our fierceness. It means speaking out when everyone says to be quiet. It means going the distance to hold perpetrators accountable for their actions. It means honoring the truth even if it means losing family, country, and friends. It means developing the spiritual mus-

cle to enter and survive the grief that violence brings and, in that dangerous space of stunned unknowing, inviting the deeper wisdom.

Like vaginas, Warriors are central to human existence, but they still remain largely unvalued and unseen. This year V-Day celebrates Vagina Warriors around the world, and by doing so we acknowledge these women and men and their work. In every community there are humble activists working every day, beat by beat to undo suffering. They sit by hospital beds, pass new laws, chant taboo words, write boring proposals, beg for money, demonstrate and hold vigils in the streets. They are our mothers, our daughters, our sisters, our aunts, our grandmothers, and our best friends. Every woman has a Warrior inside waiting to be born. In order to guarantee a world without violence, in a time of danger and escalating madness, we urge them to come out.

CELEBRATE VAGINA WARRIORS.
LET THEM BE HONORED AND SEEN. LET THEM BE BORN.

Eve Ensler
Playwright/Performer/Founder and
Artistic Director, V-Day

I took my daughter to see THE VAGINA MONOLOGUES. It was such a relief to hear it all out there in the theater with warmth, openness, and humor. When I was seventeen I couldn't talk about the vagina. It was all about silence, lies, and ignorance, and I was afraid.

Isabella Rossellini

Actor/Model
New York, NY

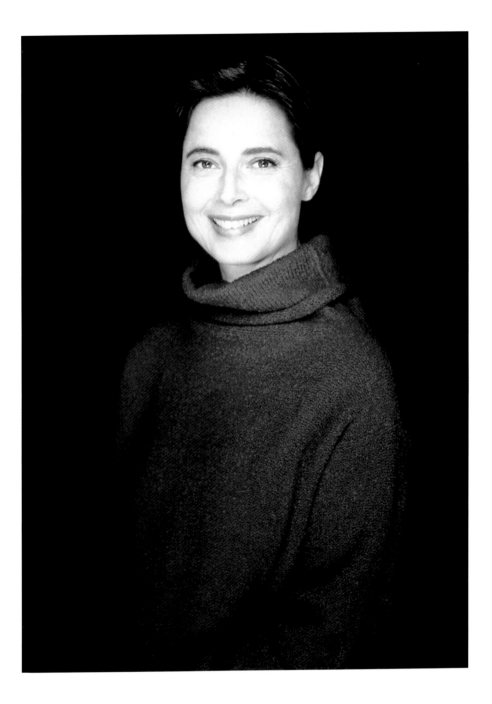

Every woman is a Vagina Warrior on the inside, but it's the people and experiences in her life that call the warrior out. The Vagina Warrior doesn't just show up to fight, as the word "warrior" suggests. Sometimes she simply shows the way.

Karen Obel

Founding College Campaign Director, V-Day
New York, NY

Our community joined us from around the country for the first all-transgender V-Day. Some people see us as less than women and less than human. This artistic and political event raised awareness about the staggering discrimination and violence faced by our youngest and most vulnerable, and highlighted some of the thousands of successful women living quiet, productive lives. We are deeply honored that Jane Fonda and Eve added our voices to this global movement.

Calpernia Addams & Andrea James

Writer/Actor Consumer Activist/Writer

Nashville, TN, and Los Angeles, CA Los Angeles, CA

I became a Vagina Warrior in 2002 after hosting the first V-Day in Kenya. Since 1997 we have empowered over 150,000 women and girls with stop-rape strategies through education and training.

Winfridah Anyango

Founder, Dolphin Anti-Rape and AIDS Control Outreach
Eldoret, Kenya

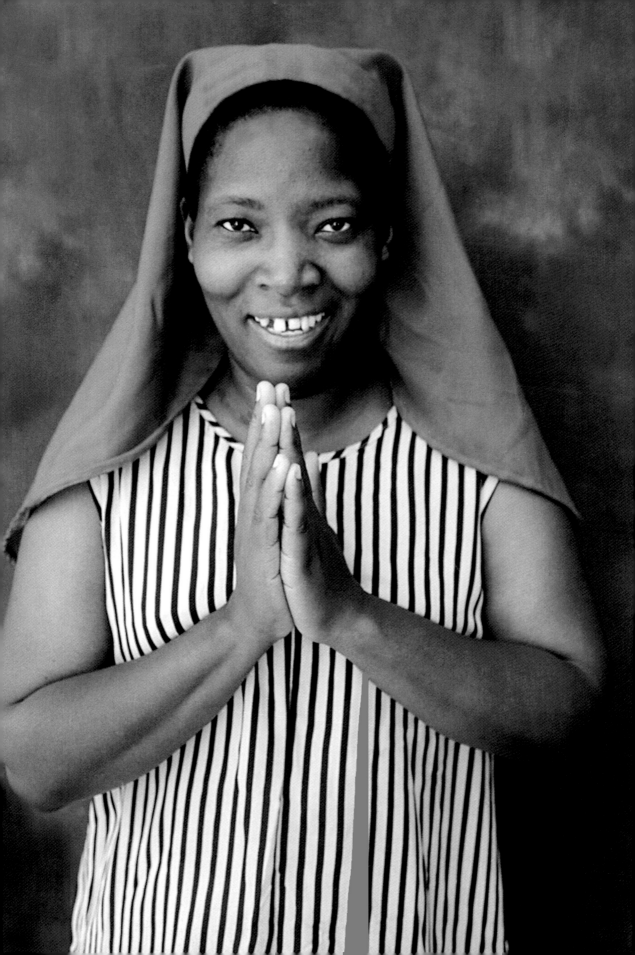

Zoya
RAWA (Revolutionary Associatio
the Women of Afghanistan
Afghanistan and Pakistan

Like vaginas,
Warriors are central to human existence, but they still remain largely unvalued and unseen.

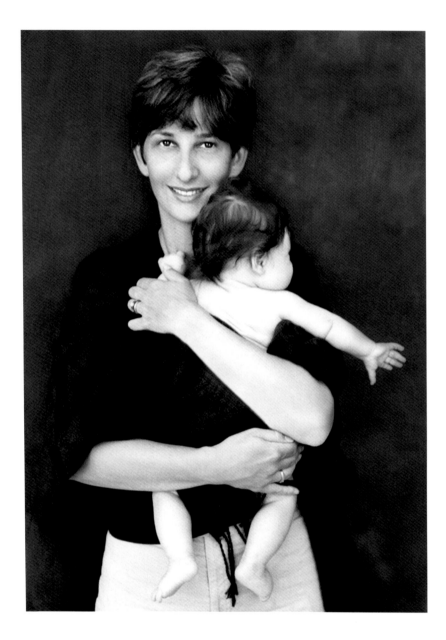

My status as a Vagina Warrior really came to fruition when I gave birth to a little girl. I fully realized how much I had to work to ensure the world will be a safe place for her.

Cecile & Tia Lipworth

Worldwide Campaign Director, V-Day
Santa Fe, NM, and Johannesburg, South Africa

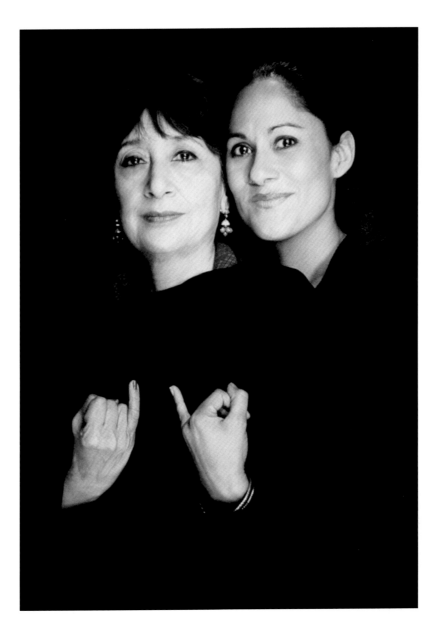

As mother and daughter we share many things, like identical little fingers. Our desire to end violence against women is equal as well.

Madhur & Sakina Jaffrey

Actor/Author Actor

New York, NY Nyack, NY

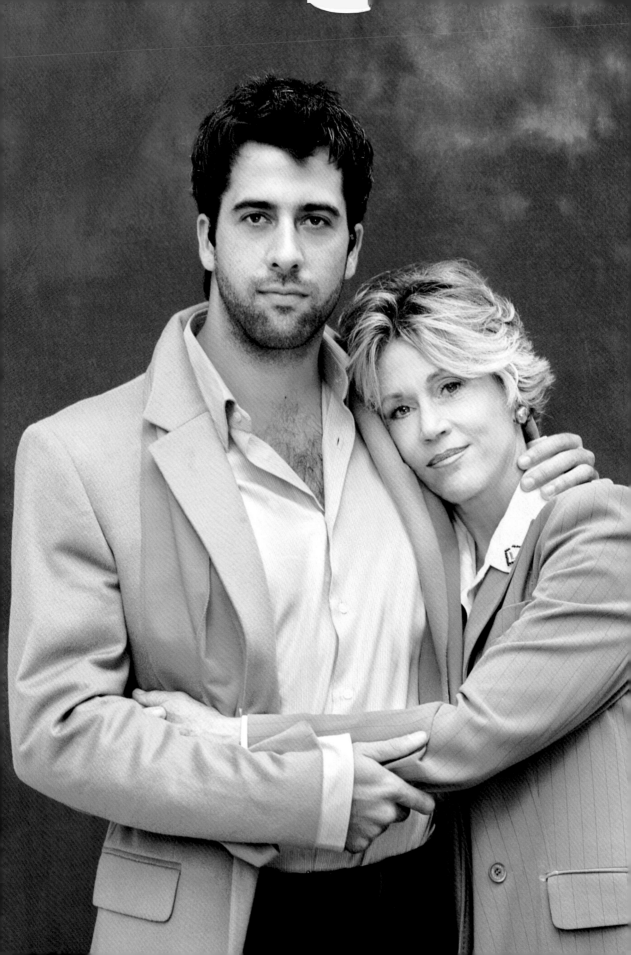

JANE: Vagina is a metaphor for love. It represents the life force. A Vagina Warrior seeks to live so fiercely in the service of that loving life force that those around her (or him)* begin to sink into their own vagina place. It is a transformational process that is contagious.

*This is not a gendered thing.

Jane Fonda & son Troy Garity

Actor/V-Counsel Actor

Atlanta, GA Los Angeles, CA

Vagina Warriors have **a keen ability** to live with ambiguity. They can hold two existing, opposite thoughts at the same time. I first recognized **this quality** during the Bosnian war. I was interviewing a

Muslim woman activist in a refugee camp whose husband had been decapitated by a Serb.

I asked her

if she hated Serbs. She looked at me as if I were crazy. "No, no, I do not hate Serbs," she said. "If I were to hate Serbs, then the Serbs would have won."

We are all different, yet we all live with the same conflict. We have not given up hope, but we are exhausted. Yet with everything, we still laugh, work, and continue to go on.

Liana Badr

General Director of Arts,
Palestinian Ministry of Culture in
Ramallah/Journalist/Teacher/Author/Director
Ramallah, Palestine

Suad Amiry, PhD

Director, RIWAQ, Centre for
Architectural Conservation/
Author/Professor
Ramallah, Palestine

Yvonne Deutsch

Co-Founder, Women and Peace in Israel/Founding
Director, Kol ha Isha (The Woman's Voice)
Multicultural Feminist Center
West Jerusalem, Israel

Rema Hammami, PhD

Author/Professor
Birzeit, Palestine

Rela Mazali

Founder, The New Profile Movement for the
Civilization of Israeli Society/Author/Educator
Tel Aviv, Israel

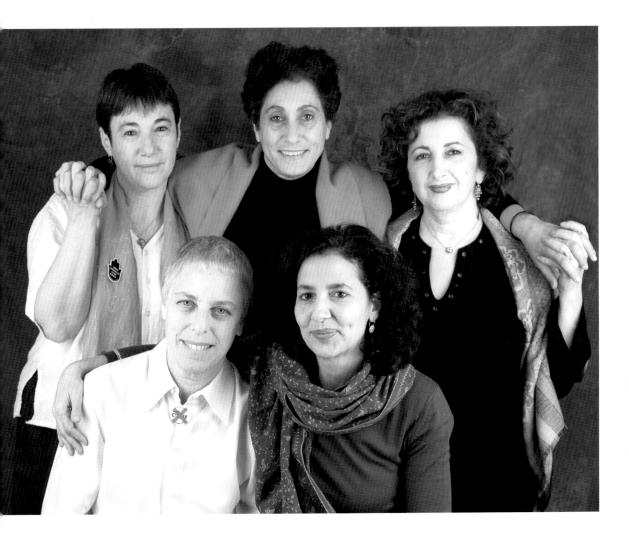

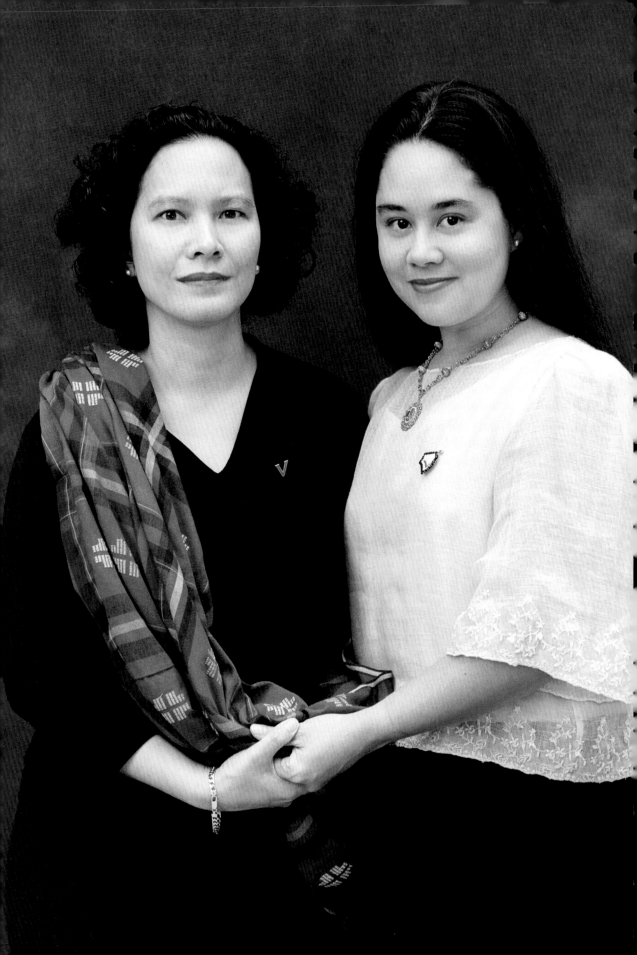

My involvement with the commercial productions of THE VAGINA MONOLOGUES in the Philippines, Hong Kong, Singapore—and, now, Japan—became the catalyst for my activism in the area of violence against women. Working with Philippine women's groups while producing the play humbled me and helped reaffirm my commitment to celebrate the voices of women in Asia.

Rossana Abueva

Banker/Executive Producer, New Voice Company
Manila, Philippines

Four years ago I watched THE VAGINA MONOLOGUES in New York, and my life changed. I heard the voice of my mother (from whom I got my Vagina Warrior spirit), which was oftentimes cut silent because of an abusive husband, and through her voice found my own. I became a V-Day organizer because I want to be sure that the voices of women and girls in the Philippines and around Asia will never be silenced.

Monique Wilson

Actor/Artistic Director, New Voice Company
Manila, Philippines

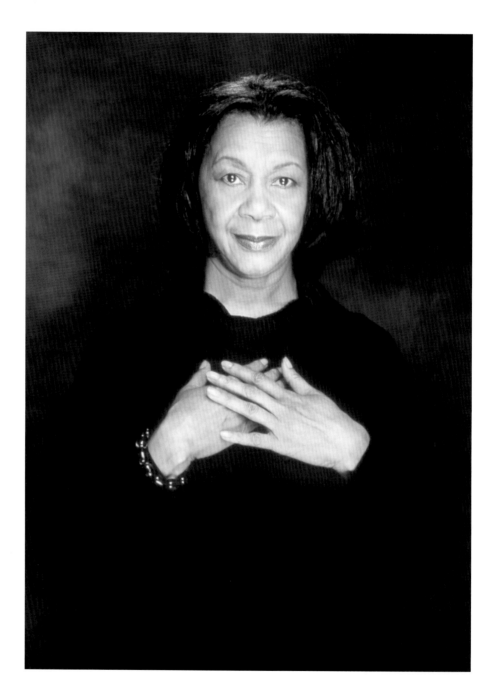

Mary Alice

Actor
Indianola, MS, and New York, NY

They are citizens of the world. They cherish **humanity** over nationhood.

We just drove three hours from Saratoga Springs, New York, where we are seniors at Skidmore College, for the V-Day regional empowerment workshop. This workshop allows us to meet other activists as well as Eve Ensler. Wow! Eve has given a voice to and empowered so many women to collaborate creatively. Producing THE VAGINA MONOLOGUES has put us in touch with people in our community who are addressing these important issues.

Jocelyn Arem & Jasmine Alvarado

Student Organizers, V-Day 2000 College Campaign, Skidmore College
Saratoga Springs, NY

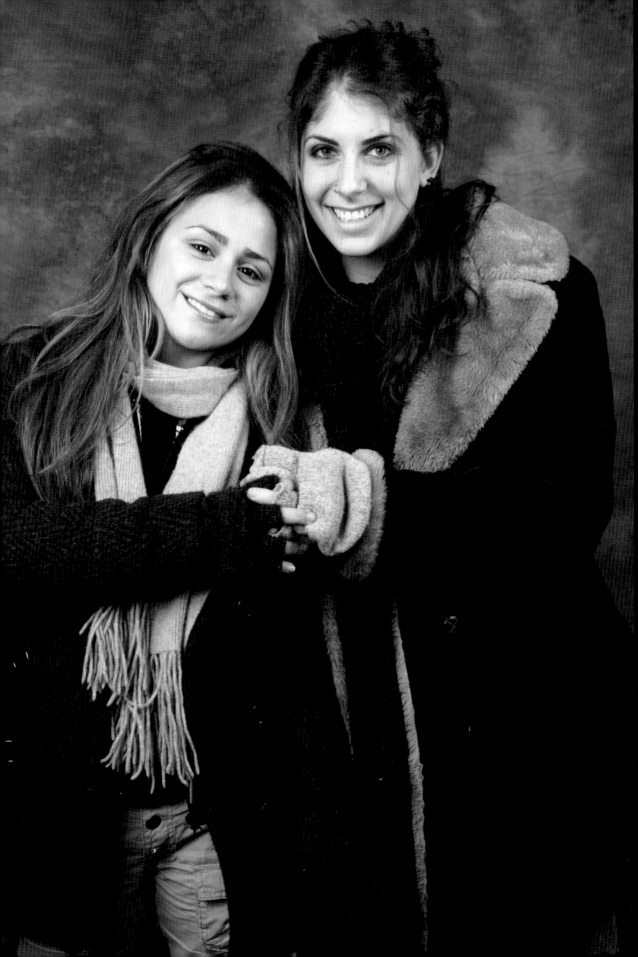

The old rule of thumb in theater is that it's best not to look directly into the faces of the audience. When I performed in THE VAGINA MONOLOGUES, I broke the rule. I looked into the eyes of the women in the audience and saw in this silent sea of faces their passion and hunger to be fully acknowledged for every part of themselves—their bodies, their souls. They, like I, were relieved to be hearing these words spoken out loud at last, with joy and with strength. It made us all Vagina Warriors!

Marlo Thomas

Actor
New York, NY

V-Day called out to me instinctively because I have a daughter. I love the energy of V-Day, the strength it gives all of us to speak in our own voices, to call out and be heard.

Eileen Fisher

Designer/V-Counsel
Irvington, NY

After seeing THE VAGINA MONOLOGUES, I realized how important the stories were and how brave these women were for telling them. My Free4Life foundation is one of the ways I am trying to combat violence with initiatives in teen dating and violence. Just by showing up for work every day I am proving that you can overcome anything and be strong.

Free

Recording Artist/VJ
Boston, MA

They are often
willing to face anything
for the safety
and freedom of others.

Lily Tomlin

Actor
Los Angeles, CA

Blending social and political awareness with song, Sweet Honey in the Rock inspires and charges listeners to action. We are women, African-American women living in what can sometimes be a world that needs our voices as its conscience. As warriors for justice, dignity, and equality for ALL people, Sweet Honey in the Rock and V-Day celebrations are a natural fit.

Sweet Honey in the Rock

Recording Artists
Washington, D.C.

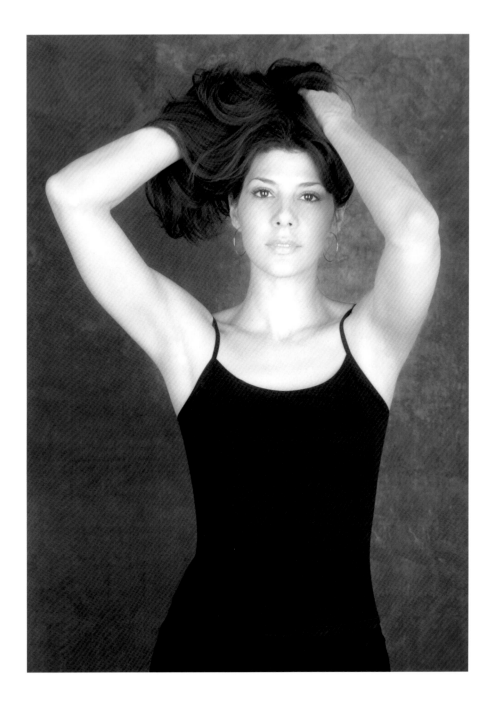

Marisa Tomei

Actor
Brooklyn, NY

Vagina Warriors know **that the process** of healing from violence is long and happens in stages. **They give** what they need the most, and by giving this **they heal** and activate the wounded part inside.

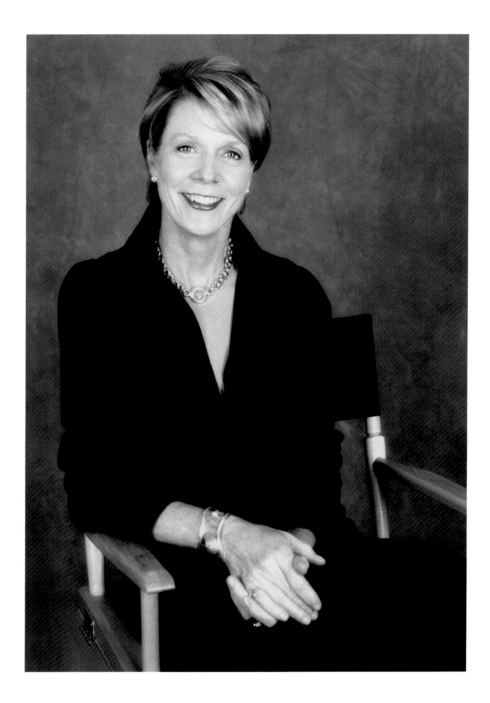

Cathleen Black

President, Hearst Magazines/V-Counsel
New York, NY

They have experienced their rage, depression, and **desire for revenge** and they have transformed them through grieving and service. They have confronted **the depth of their darkness.** They live in their bodies.

As an Indian American, as a doctor, as a community activist for women's issues, I find myself in regular contact with women surviving violence. After decades of watching fellow physicians, immigrants, and community members remain silent, I have come to realize that change can only occur when we learn to be articulate and educated and speak out.

Bhaswati Bhattacharya MPH, MD

Holistic MD/Author
Kolkata, India, and New York, NY

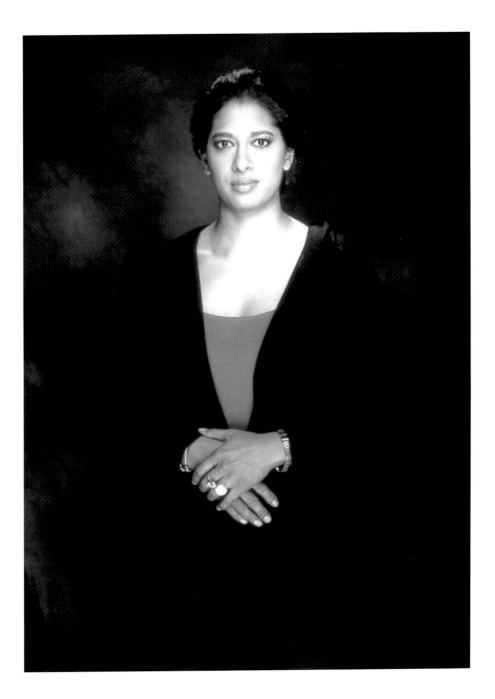

Emotional, intellectual, spiritual, physical. It requires every bit of our strength, our courage, our fierceness. It means speaking out when everyone says to be quiet. It means going the distance to hold perpetrators accountable for their actions.

It means honoring the truth even if it means losing family, country, and friends. It means developing the spiritual muscle to enter and survive the grief that violence brings, and in that dangerous space of stunned unknowing, inviting the deeper wisdom.

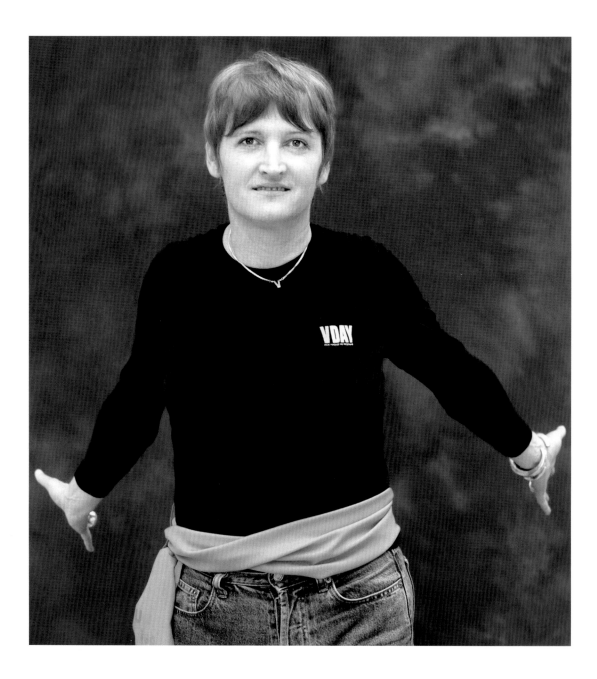

I became a Vagina Warrior by singing with women in refugee camps, by not being frightened crossing war borders with other women, by protecting my neighbor from her violent husband, by hugging my niece Ana and knowing she is safe with me. It is a process. I grew into my power.

Rada Boric

Regional Coordinator for Bosnia and Herzogovina and Croatia, V-Day
Professor/Editor/Author
Zagreb, Croatia, and Helsinki, Finland

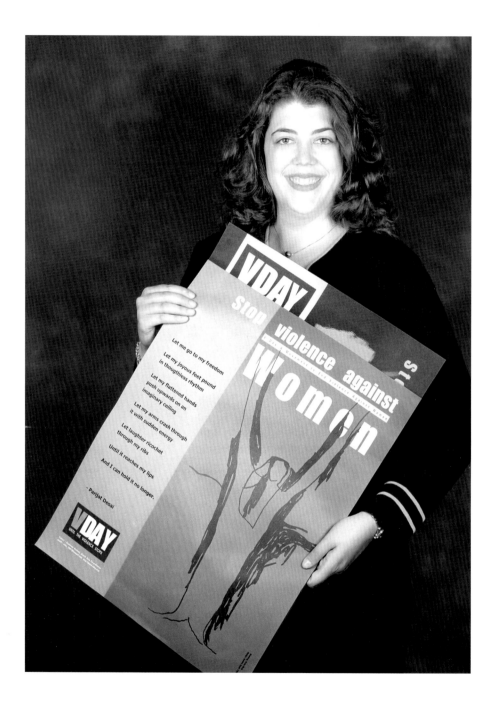

Allison Prouty

Events Producer/Executive Assistant to the
Artistic Director, V-Day
New York, NY

They know that punishment does not make

abusive people behave better.

MYUNG HEE CHO: One of my proudest achievements is to be a member of the V-Force that is making such a difference in the lives of women and girls around the world.

Myung Hee Cho & Eve Ensler

V-Day Designer/Scenic Designer
Coto de Caza, CA, and New York, NY

Playwright/Performer/Founder and
Artistic Director, V-Day
New York, NY

As a Vagina Warrior, I say to endangered women everywhere, "Let me hold your broken wing while you fly." I volunteer at the Bedford Hills Correctional Facility, where I lead a writing workshop for women ages seventeen to twenty-three entitled "Journey Within." The work empowers young women to stand in the present, forgive the past, and dare to choose a new future.

Hazelle Goodman

Actor
New York, NY

JESSICA: I started getting involved with women's issues when I arrived at Princeton. This is my fourth V-Day production of THE VAGINA MONOLOGUES. Jade and I are co-organizing the 2004 production of THE VAGINA MONOLOGUES. We've raised approximately $25,000, which we will donate to Womanspace in Trenton, a crisis center for domestic violence.

AMY: I learned how to use computers and the Internet within a close circle of girlfriends who empowered me with information and taught me the value of online community. We used e-mail and the Web to share stories and art, to keep each other aware of injustice, and to organize action. My work as a Vagina Warrior is to use technology to facilitate communication and mobilize other Warriors for the fight against violence.

Jessica Brando, Jade Guanchez & Amy Squires

Student Organizers, V-Day 2004 College Campaign, Princeton University, Princeton, NJ

Web and Online Community Director, V-Day Brooklyn, NY

They have a wicked sense of humor. A Palestinian activist told jokes to an Israeli soldier who pointed a machine gun at her as she tried to pass the checkpoints. She literally disarmed him with her humor.

Kim Crenshaw

Professor of Law, Columbia University and UCLA
New York, NY, and Los Angeles, CA

Violence touches the lives of one in three women around the world. As CEO of Lifetime Television, I am dedicated to using the power of the media to inform and support women on the issues most important to them and their families. It is my privilege, and responsibility, to work toward a day when women and children are safe in their homes and communities.

Carole Black

President and CEO, Lifetime Entertainment Services/V-Counsel
New York, NY

Those of us who have been abused have a responsibility to turn something horrible into something positive, by sharing our stories. My abusers will never know how I have used that terrible experience to empower myself to help others. I have turned ugliness into beauty by becoming a Warrior.

Denyce Graves

Opera Singer/Radio Talk Show Host/Businesswoman
New York, NY

I always suspected the existence of Vagina Warriors—in others, in my mother, my sister, myself. Through THE VAGINA MONOLOGUES, Eve provided Vagina Warriors worldwide with a manifesto AND with our very own language, with a vehicle for change and the passionate energy to fuel it. What is uncanny is that Vagina Warriors instantly recognize one another when they meet. It is a spirit, a vibe, a feeling: Vagina Warriors are everywhere and they are fierce. Regardless of nationality or location, we speak the same language and move at the same rapid pace. Working together is both an honor and a joy.

Susan Celia Swan

Media and Communications Advisor, V-Day
New York, NY

Since I began working with V-Day, I've learned that Vagina Warriors take all forms. For me, as a survivor of molestation and date rape, I have found that dedicating myself to raising funds and awareness and providing an infrastructure for thousands of women and men around the world to build this movement makes me "Warrior" material. We all need to find our own unique way to make a difference.

Jerri Lynn Fields

Executive Director, V-Day
Westchester County, NY

JOYCE: I've always seen myself as a spiritual warrior—someone who is not afraid to stand up for her inner beliefs. Photographing the portraits for V-Day has enlarged my world and given me the chance to meet extraordinary people. Violence against children is one of the cruelest crimes imaginable. As mothers and grandmothers, we must use our power to help end this global cycle of violence.

Joyce Tenneson & Shael Norris

Author/Photographer
New York, NY

College Campaign Director, V-Day
Bronx, NY

I became a Vagina Warrior the moment I realized that certain assaults against my femininity, and my very being, were not my fault. The moment I saw THE VAGINA MONOLOGUES, I committed myself to helping free other women from thinking they must bear those assaults alone.

Cynthia Garrett

Actor/Television Personality
Los Angeles, CA, and New York, NY

Pat Mitchell

President and CEO, PBS (Public Broadcasting Service)/V-Counsel
Washington, DC

They are fierce, obsessed, can't be stopped, driven.

LISA: I have always considered myself a warrior. As an African-American woman, I have always worn my armor proudly, fighting and educating those who fear me and my community. There was an essential part of myself, however, that I kept hidden, unexplored, and silenced.

Then one evening, I sat in a small theater and was awakened to my beautiful and wondrous vagina by the glorious and courageous MIGHTY VAGINA WARRIOR, Eve Ensler. Now I am a Vagina Warrior as well, mentoring young girls who have been or currently are in abusive relationships.

LisaGay Hamilton & S. Epatha Merkerson

Actor/Co-Producer, V-Day Harlem 2002
Los Angeles, CA

Actor
Detroit, MI

Since my daughter, who is now five, came into my life, I have felt an urgency to instill in her a sense of her own power as a woman—power over her own body, her mind, and her soul. I became a Warrior in order to provide an example to her so she could be the daughter of a Warrior and know that is also her own destiny.

Amy Hill

Actor
Los Angeles, CA

In Germany I helped initiate an awareness program on sexual violence in a simple manner. I enlisted bakeries to put help-line phone numbers on all their bread wrappings, which were then distributed to women throughout our country.

Karin Heisecke

Organizer, V-Day Europe/Winner, 2001 V-Day Stop Rape Contest/UNFPA
Idar-Oberstein, Germany, and Brussels, Belgium

JOAN: My sister is my best friend. We share a belief that our bodies give us strength and a means to open our hearts to the joys of life. We will fight to help ourselves and other women honor this treasure so that we can continue to feel truly alive.

Joan Steinberg & Snookie DeGraff

Philanthropist/V-Counsel
New York, NY

Family Nurse Practitioner/Yoga Instructor
Seattle, WA

Lisa Leguillo

Actor
Brooklyn, NY

For native people,
a warrior is one
whose basic responsibility is
to protect
and preserve life.
The struggle to
end violence
on this planet is a battle.

Being a Vagina Warrior is like going through all of the "red lights" of your life and never once looking back. Vagina Warriors are unstoppable. Being a Vagina Warrior is a state of mind where everything is possible, and every obstacle beckons with potential. I am constantly connected to the pain of other women. I am constantly appreciative of other women's work. There is no need for me to speak with other women of the world, because we are all connected by a fundamental and inextricable web of experience. Yet, we do speak, we must speak. As a Vagina Warrior, I feel my mandate is to bridge perceived gaps between women—gaps of understanding, gaps of ignorance, gaps of fear, gaps of isolation and loneliness. I am a Muslim Vagina Warrior, I am African, I am Western, I am a citizen of the World. I embrace the experience of women all over the world, and as a Vagina Warrior I help them realize that we are one, that united we can face anything. It is a feeling. It is action. Every woman's story is my story, too. Moving forward. Never looking back.

Hibaaq Osman

Special Representative to Asia, Africa, and the Middle East, V-Day
Somalia, Washington, D.C., and Cairo, Egypt

Mariposa

Poet/Performance Artist/Actor/Author/Painter/Educator
Bronx, NY

They are
not afraid
to be alone,
not afraid to be
ridiculed
or attacked.

While directing UNTIL THE VIOLENCE STOPS, I traveled to many countries and cities, documenting the grassroots import of THE VAGINA MONOLOGUES and V-Day. At the film screenings, the audiences have been devastated by the violent stories recounted, but they have also been uplifted and empowered by the hope that ending violence is possible.

Abby Epstein

Filmmaker/Theater Director/Director, UNTIL THE VIOLENCE STOPS
New York, NY

After being with Eve in Bosnia, life was never the same. She showed another lens to look at humanity with, and it stays deep in your soul.

Beth Dozoretz

Vice Chair, Harvard University Center for Public Leadership/Philanthropist/V-Counsel
Washington, DC

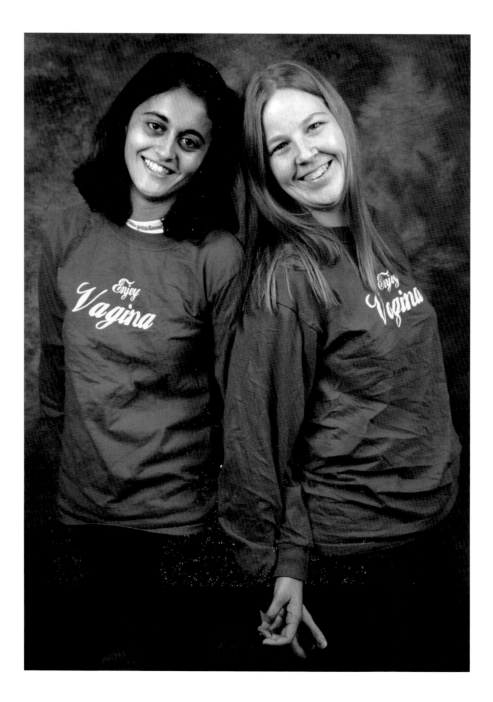

We made these shirts two years ago—they inject a bit of humor into an otherwise serious issue. I think what I love most about the V-Day campaign is that it dares us to imagine a world without rape, to believe such a world is possible.

Shereen Katrak

Student Organizer, V-Day 2004 College Campaign
Massachusetts Institute of Technology
Cambridge, MA

At MIT, violence against women is rarely spoken about. THE VAGINA MONOLOGUES offers a unique voice for women who would not otherwise tell their stories.

Vagina Warriors

are done being victims.
They know
no one is coming to
rescue them.
They would not want
to be rescued.

Suze Orman

Personal Finance Expert/Author
South Florida, FL

I was honored to open the first "three-woman" production Off Broadway of THE VAGINA MONOLOGUES in New York. What an extraordinary event for the actors as well as the audience. I also participated in other V-Day events—like the one at Madison Square Garden, where over eighteen thousand people were talking about and hearing about vaginas. Vaginas will never be the same again.

Julie Kavner

Actor
Los Angeles, CA

When I was in high school, I met my first Vagina Warrior when I traveled to Kenya with V-Day. At age sixteen, Mary had already endured the cruelest forms of abuse: female genital mutilation, being taken out of school, abuse by her father, a forced marriage to a fifty-year-old man, and the birth of a baby after she was raped. Yet, despite it all, she still had the biggest, most sincere smile on her face, and she showed me the enormous strength of the female and human spirits. Mary brought out the Vagina Warrior in me that day, and ever since, I've been producing V-Days, first at my high school and now at my college, to raise money to pay for her tuition as well as to help other domestic and international grassroots organizations end violence against women. Her strength has helped me accomplish things I never knew I was capable of. Anyone can raise money for a cause, but there's no material equivalent or amount of money that compares to knowing that you've changed someone's life for the better, and that they've changed yours.

Molly Kawachi

Organizer, V-Day 2004 College Campaign, Connecticut College,
and V-Day 2002 Worldwide Campaign, Fieldstone Academy
New London, CT, and New York, NY

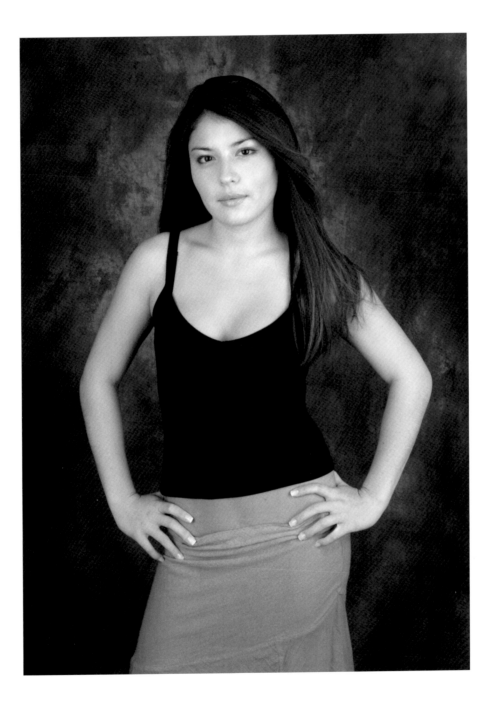

Marie Cécile Renaud & Mary F. Morten

Literary Agent/V-Day Europe/French Producer
of THE VAGINA MONOLOGUES
Paris, France

Worldwide Campaign Organizer,
V-Day Chicago 2002–2004
Chicago, IL

In order to guarantee **a world** without violence, in a time of danger and escalating madness, we urge them to come out.

I became a Vagina Warrior after seeing THE VAGINA MONOLOGUES and getting the opportunity to be a part of them. It really changed my life. Eve is my "shero" for taking what many might see as a personal tragedy and transforming it into a global victory.

Tonya Pinkins

Actor/Co-Founder, Operation Z: Zero Tolerance of Violence Against Women and Children
New York, NY

VALERIE: I am a domestic violence survivor, after living with my abusive husband for seven years. In 2001, my sister decided to participate in the V-Day "Stop Rape Contest" based on my history. That February 10th changed our lives. The next year, we produced a sold-out V-Day benefit performance of THE VAGINA MONOLOGUES in Guatemala. Today, we continue supporting women who need emotional recovery through projects that protect their rights.

Valerie & Marsha Lopez Calderon

Organizers, V-Day 2002 Guatemala
Guatemala City, Guatemala

They know that it is more important to provide a space where the best can emerge rather than "teaching people a lesson." I met an extraordinary activist in San Francisco a former prostitute

who had been abused **as a child.** **Working with the** correctional system, **she devised a** therapeutic workshop where convicted pimps and johns **could confront their loneliness,** insecurity and sorrow.

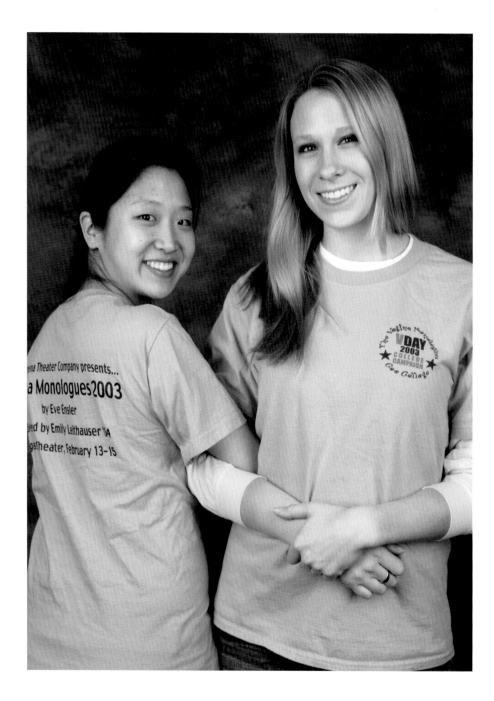

I had an eating disorder that was killing me. Being involved in V-Day has given me an environment where women can talk and revere their bodies. Participating in the V-Day regional empowerment workshop has been such a blessing.

Kathy Lee

Student Director, V-Day 2004 College Campaign
Harvard University
Cambridge, MA

I've always been a person who has a lot of compassion for others. Directing this year's production of THE VAGINA MONOLOGUES allows me the chance to use this compassion for an important cause.

In my country we are told that good women shouldn't even talk about honor killings and that they don't exist. But I am here, talking. Women come to hide in my house. I want to help women go from weak and afraid to strong and outspoken, having full control over their own voice. Now we have voices in Iraq that cannot be silenced easily. We will keep on fighting until the violence stops.

Yanar Mohammed

Chairperson, Organization of Women's Freedom in Iraq/
Editor in Chief, AL MOUSAWAT (Equality) Newspaper
Baghdad, Iraq

They love to

dance.

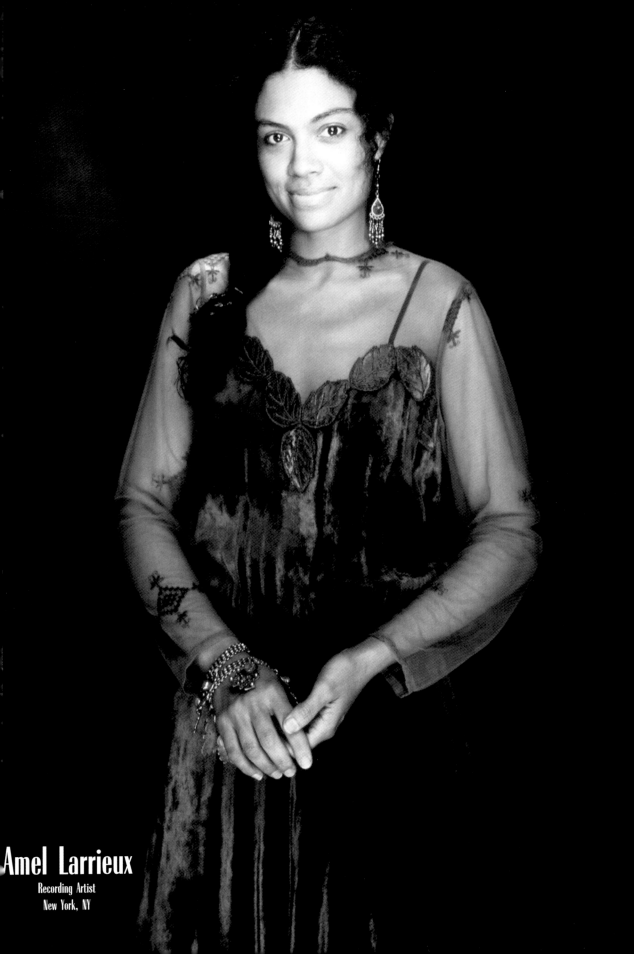

Amel Larrieux
Recording Artist
New York, NY

ANU: My mother wanted me to be a boy. In India girls are not valued as much as boys. My goal now is to become a women's rights lawyer. I've learned to be strong and proud of myself even without my mother's approval. I met Laura and Jenny at a V-Day regional empowerment workshop and we have become friends.

Anu Ahuja, Jenny Basa & Laura Cote

Student Organizers, V-Day 2004 College Campaign, Lesley University
Cambridge, MA

For almost thirty years, I have traveled with my cameras. I have witnessed the determination of women in Chile searching for their disappeared relatives; the courage of girls in Kenya refusing to be genitally mutilated; the perseverance of women in Kosovo reclaiming their war-torn lives; and the loving spirit of women in Afghanistan meeting secretly despite potentially grave consequences. What I have learned is that the world is filled with Vagina Warriors who refuse to be silenced, buried, or contained, and because of this, violence against women is not inevitable.

Paula Allen

Photographer
New York, NY

I was born a Vagina Warrior. I've never been happy with the status quo. The V-Day movement is fighting for what is right and to be free. Freedom is my idea of happiness.

Mellody Hobson

President, Ariel Capital Management, LLC/Ariel Mutual Funds/V-Counsel
Chicago, IL

Many Vagina Warriors work primarily on a grassroots level. Because what is done to women is often done in isolation and remains unreported, Vagina Warriors work to make the invisible seen. Mary in Chicago

fights for the rights of Women of Color so that they are not disregarded or abused; Nighat risked stoning and public shaming in Pakistan by producing THE VAGINA MONOLOGUES in Islamabad so that the stories and passions of women would not go unheard; Esther insists that the hundreds of disappeared girls in Juárez are honored and not forgotten.

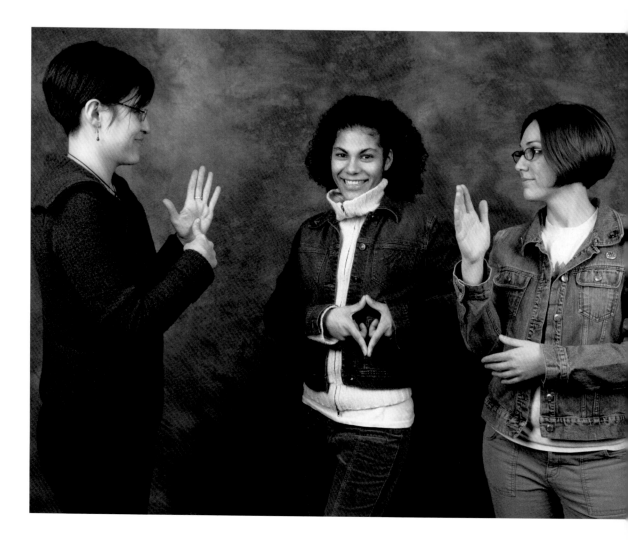

LUCY: At the Rochester Institute of Technology, the V-Day production of THE VAGINA MONOLOGUES is performed in both English and American Sign Language. The cast is doubled, and both groups of actresses perform the show simultaneously, drawing an audience of five hundred people. Members of the cast share the perceptions of violence in both the deaf and non-deaf community. In this picture our hands are saying "Show me THE VAGINA MONOLOGUES."

Lucy Annett, Kelly Lenis & Laura McNamara

ASL Interpreter
Boston, MA

Stage Managers, V-Day 2004 College Campaign
Rochester Institute of Technology
Rochester, NY

They are no longer
beholden to
social customs
or inhibited by
taboos.

Starla Benford

Actor

Austin, TX, and New York, NY

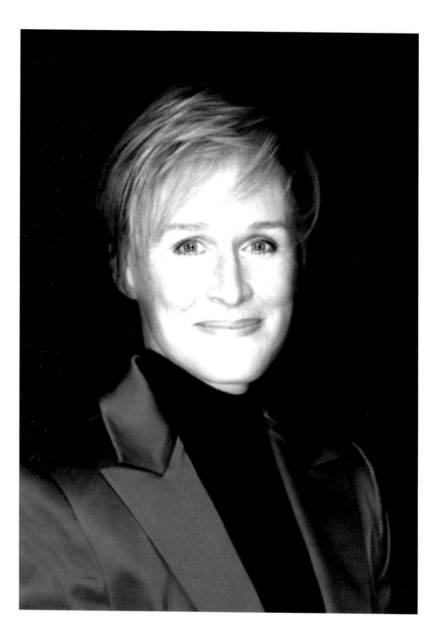

You don't just hook up with Eve, you become part of her crusade. There's a core of us who are Eve's army.

Glenn Close

Actor
New York, NY

Being part of V-Day has made my voice stronger, has made me stand taller, has made me feel part of a powerful, loving, global sisterhood.

Christine Lahti

Actor
Los Angeles, CA

I consider inequality the primary form of violence. In France, land of the Declaration of the Rights of Man, we must fight every day to ensure that this fundamental document becomes a reality and to ensure that every woman is granted equal rights. My daily battle is the fight for equality.

La Première Violence pour moi est celle de l'Inégalité. En France, Pays de la Déclaration des Droits de l'Homme, nous devons, toutes et tous, chaque jour, lutter pour que ce Texte fondateur soit une Réalité et pour que chaque Femme vive dans l'Egalité de ses Droits. Depuis 1789, nous passons de discours déclamés en lois non appliquées. La lutte pour l'Egalité, c'est chaque jour mon combat.

Claude Boucher

Director, Les Amis du Bus des Femmes
Paris, France

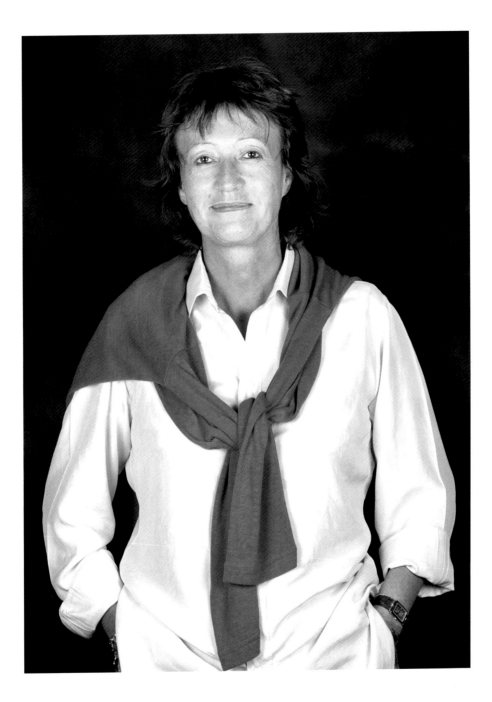

They are our mothers, our daughters, our sisters, our aunts, our grandmothers, and our best friends. Every woman has a Warrior inside waiting to be born.

Kevsera Memedova & Memnuna Zvizdic

Co-Founder, Association of Roma Women/ESMA
Skopje, Macedonia

Project Manager, Center Zene Zenama/Coordinator,
V-Day Sarajevo 2003
Sarajevo, Bosnia

As an organizer for V-Day in Italy, I have learned that there are abuses that leave visible signs, but also those that are subtler. These abuses are less visible because they are passed along without words and silently accepted. Rome is the symbol of a religious power that has taken centuries and centuries to recognize and give women the right to a soul.

Nicoletta Billi

Freelance Cinema Publicist/Coordinator, V-Day Rome, and V-World Summit
Rome, Italy

In 2002 I helped produce V-Day San Francisco, which raised $500,000 in one evening in a sold-out thirty-five-hundred-seat theater. The money was distributed among twenty-four anti-violence organizations. I am now fighting to stop violence against women and girls by fostering debate and dialogue among young people and supporting Democratic women candidates to run, win, and stand up for the rights and safety of women and children.

Noelle Colome

Coordinator, V-Day San Francisco 2002/Board Member, EMERGE/Zephyr Real Estate
San Francisco, CA

Ricki Lake

Actor/Television Talk Show Host
New York, NY

In every community there are humble activists working every day, beat by beat to undo suffering. They sit by hospital beds, pass new laws, chant taboo words, write boring proposals, beg for money, demonstrate and hold vigils in the streets.

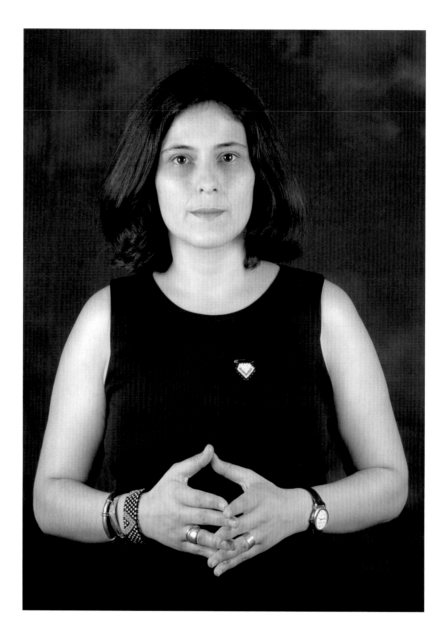

I was part of an international team of women from various Balkan and East European countries who initiated and organized a regional V-Day in Sarajevo. It was the first time many of the women from these countries had ever come together. The performance was in multiple languages and was particularly moving, as it was held ten years after the Bosnian war and on the eve of the war on Iraq.

Marianna Katzarova

Researcher, Amnesty International—The Russian
Federation/Organizer, V-Day Sofia and Balkans
Sofia, Bulgaria, and London, England

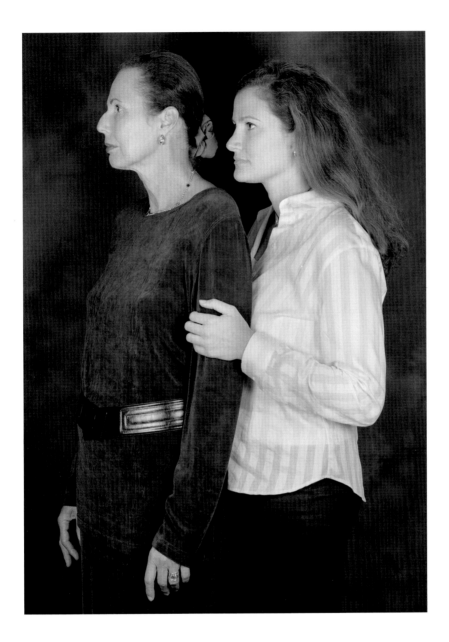

LINDA: I was one among eighteen thousand in the stands of Madison Square Garden at V-Day 2001. I felt Eve's energy reach out and I was converted forever. Now I consider myself a Vagina Warrior, promoter, and conservationist.

Linda & Lisa Schejola

Philanthropists
Milan, Italy, and New York, NY

I first became a Vagina Warrior to be part of the healing process and to help those in pain stand tall. Then I became a Vagina Warrior to be part of healing my own pain so that I could honestly stand tall with them. It feels so sweet to let the pain go and be with my Warrior brothers and sisters, standing, falling, slipping, sliding, and healing all together.

Rosie Perez

Actor/Producer
Brooklyn, NY

They are
community makers.
They bring
everyone in.

Rosario Dawson
Actor
New York, NY, and Los Angeles, CA

Violence against women and girls in Indian country is at epidemic proportions. As I recognized the need to raise consciousness, awareness, and money around issues facing Native American women, I joined V-Day to help build coalitions to strengthen tribal commitments to end violence.

Suzanne Blue Star Boy

Founding Director, V-Day Indian Country Project
Ihanktonwan (Yankton, SD)

As a result of V-Day support we have empowered hundreds of thousands of women and girls in Kenya. We opened a safe house where girls can go to escape female genital mutilation. I drive around from village to village in a jeep with an anatomical model so I can show our people what happens to their young girls when they are forced to undergo genital cutting. This causes chronic infections, possible infertility, shock, and lifelong trauma.

Agnes Pareyio

Founder, V-Day Safe House for the Girls
Narok, Kenya

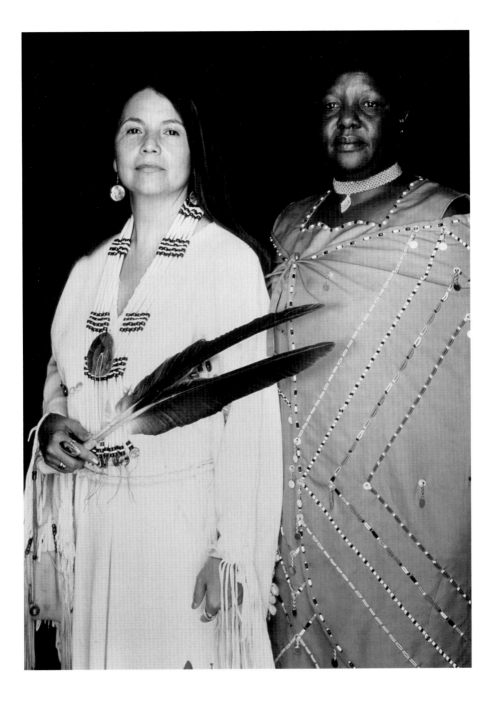

Coming from a war-torn country, I believe I always carried the Vagina Warrior seed in my being. Meeting Eve and seeing her work in New York shelters and her work in Bosnia nourished the seed in me and allowed my anger and compassion to be manifested as warriorhood. I feel more than ever the deep, passionate need to stop brutality toward women and children. Being a mother now has only intensified my need for Peace.

Shiva Rose

Actor
Los Angeles, CA, and Tehran, Iran

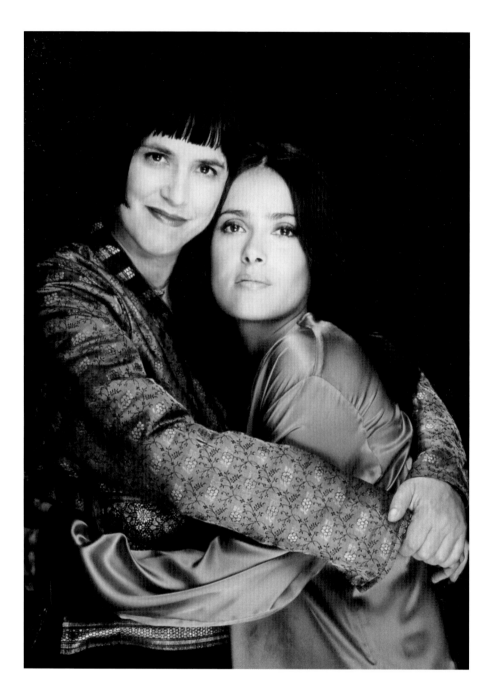

Eve Ensler & Salma Hayek

Playwright/Performer/Founder and
Artistic Director, V-Day
New York, NY

Actor/Producer/Director
New York, NY

Vagina Warriors know
that compassion is
the deepest
form of memory.

I was a secret Vagina Warrior as a little girl. That's because I was lucky enough to have parents who treated me as if I had a will of my own, and who traveled so much that I escaped the brainwashing of going to school. Then school, adolescence, and male-dominant realities hit all at once. I wasn't truly rebellious again until I was in my thirties.

That was when the women's movement came into my life and showed me that women together could stand up against unfairness and humiliation and violence. This contagion of self-respect saved my life and taught me to look at the world as if women mattered. I knew then that I would spend the rest of my life returning the favor.

Gloria Steinem

I am a Vagina Warrior because my life's project is to fight against violence that destroys and scars women for life, to start to end this war that women have to fight in their own homes, to sow a ray of hope in the hearts of women and girls who have been violated.

MI PROYECTO DE VIDA ES EL DE V DAY "HASTA QUE LA VIOLENCIA TERMINE" PARA LUCHAR CONTRA LA VIOLENCIA FAMILIAR, MAL QUE AVANZA, DESTRUYE Y MARCA. PARA SEMBRAR UNA LUZ DE ESPERANZA EN EL CORAZON DE LAS MUJERES Y NIÑAS VIOLENTADAS. PARA COMPARTIR EL LLANTO Y DOLOR DE LAS MUJERES VIOLENTADAS. PARA PONER FIN A LA GUERRA QUE VIVEN LAS MUJERES DENTRO DE SUS HOGARES.

Esther Chavez Cano

Founder, Casa Amiga
Juárez, Mexico

They are directed
by vision,
not ruled by ideology.

Eve
Recording Artist/Actress/Fashion Designer
Philadelphia, PA

Va•gi•na War•rior N.

A woman or man committed to or working toward ending violence against women and girls.

One in three women will experience violence during her lifetime. (United Nations Population Fund 2000)

Violence against women is happening everywhere. It is personal, local, and specific. It is indiscriminate of class, age, neighborhood, and race. Women are raped in plush hotel suites, city parks, college dorms, and deserted streets. Women are beaten in thatched huts, high-rise apartments, trailer parks, and suburban split-levels. They are sold into sexual slavery, burned with acid, abducted, abused, and mutilated. Although the specific patterns of violence against women change across cultural lines, most people have come to expect it, make room for it, and accommodate it, as if it were an immutable given of the human condition; it has become acceptable.

V-Day insists that women spend their lives creating and thriving rather than recovering and surviving.

Since V-Day launched its first event in 1998, the movement has been led by fierce, passionate, and generous women working to end violence against women and girls in their communities. They are Vagina Warriors. These women, often survivors of violence themselves, are dedicated to ending violence through grassroots means. They have been at the heart of V-Day since its conception as a worldwide movement to empower and enable activists to raise awareness and funds locally through V-Day benefit productions of THE VAGINA MONOLOGUES.

Vagina Warriors are everywhere. In 2004 alone, twenty-three hundred V-Day benefit events took place in over eleven hundred communities around the world raising money for local groups working to end violence against women and to educate people about the reality of violence against women and girls. With this book, we offer a sampling, a taste, an idea. Let it be a gift, a reminder, an inspiration, a call to be brave. Celebrate Vagina Warriors in your community. Make them visible. Empower them. Join them.

THE MAJORITY OF THE PORTRAITS IN THIS BOOK WERE SHOT ON LOCATION AT A SERIES OF V-DAY EVENTS, INCLUDING: V-DAY NYC 2002; V-DAY HARLEM 2002; THE V-WORLD SUMMIT IN ROME, SEPTEMBER 2002; AND THE V-DAY REGIONAL EMPOWERMENT WORKSHOP IN BOSTON, DECEMBER 2003.

V-Day is a radical idea, a catalytic force, a deeper imagining. It is an invitation. It is the power to envision the place we are going and the energy required to take us there.

For seven years, V-Day has been growing, gathering women from around the world and inspiring V-productions in over seventy-six countries. We are working together with the families of the raped and murdered women from Juárez, Mexico; sex-trafficked women from Paris, Bulgaria, and Manila; date-raped women on college campuses all over North America; acid-burned women in Pakistan; communities of the honor-killed women in Jordan; battered women in the corporate world; genitally mutilated women in Kenya; and women slowly being made extinct through gender genocide and war in Afghanistan and Iraq. Women, with their strength, grace, integrity, outrage, honor, and courage, are creating a global community that is changing the world.

V-DAY

V-Day is a global movement to end violence against women and girls, inspired by playwright/performer/V-Day founder Eve Ensler's award-winning play THE VAGINA MONOLOGUES. V-Day is a catalyst that promotes creative events to increase awareness, raise money, and revitalize the spirit of existing antiviolence organizations. V-Day directs broader attention toward the fight to stop worldwide violence against women and girls, including rape, battery, incest, female genital mutilation (FGM), and sexual slavery.

V-Day stages large-scale benefits and produces innovative gatherings, films, and programs to educate, inform, and change social attitudes toward violence against women. These include the 2004 documentary UNTIL THE VIOLENCE STOPS; community briefings with Amnesty International on the missing and murdered women of Juárez, Mexico; the December 2002 V-Day delegation trip to Israel, Palestine, Egypt, and Jordan; the Afghan Women's Summit, co-sponsored by Equality Now; the Stop Rape Contest; and the Indian Country Project.

Through V-Day campaigns, local volunteers and college students produce annual benefit performances of THE VAGINA MONOLOGUES to increase consciousness and raise funds for antiviolence groups within their own communities. The V-Day movement is rapidly growing throughout the world. V-Day, a nonprofit corporation, distributes funds to grassroots, national, and international organizations and programs that work to end violence against women and girls. In 2001, V-Day was named one of WORTH magazine's "100 Best Charities." In its first seven years, the V-Day movement has raised over $25 million.

The "V" in V-Day stands for victory, valentine, and vagina.

2004	2,300 events	$25,000,000 raised*
2003	1,000 events	
2002	800 events	
2001	250 events	
2000	160 events	
1999	70 events	
1998	1 event	

*In addition to the millions raised by V-Day benefit productions of THE VAGINA MONOLOGUES, commercial and touring productions of THE VAGINA MONOLOGUES donated a portion of each ticket sold to V-Day, amounting to millions of dollars to end violence against women and girls. Warm thanks to David Stone, The Road Company, and Dramatist Play Service.

V-Day events have taken place in the following countries:

Angola	Egypt	Lebanon	Poland
Argentina	England	Lesotho	Puerto Rico
Australia	Ethiopia	Lithuania	Romania
Austria	Finland	Luxembourg	Scotland
Barbados	France	Macedonia, The Former	Singapore
Belgium	Gambia	Yugoslav Republic of	Slovakia
Bosnia and Herzegovina	Germany	Malaysia	South Africa
Botswana	Ghana	Mali	Spain
Bulgaria	Gibraltar	Malta	Sweden
Burkina Faso	Guam	Mexico	Switzerland
Cameroon	Hong Kong	Namibia	Togo
Canada	Iceland	Netherlands	Trinidad and Tobago
China	India	New Zealand	Turkey
Congo, The Democratic	Indonesia	Nicaragua	United States
Republic of the	Ireland	Northern Ireland	Virgin Islands, U.S.
Costa Rica	Israel	Peru	Wales
Croatia	Italy	Pakistan	Yugoslavia
Czech Republic	Jamaica	Palestinian Territory,	Zaire
Denmark	Japan	Occupied	Zimbabwe
Ecuador	Kenya	Philippines	

VICTORIES

What follows is a brief snapshot of the many V-Day victories that have taken place since 1998, illustrating the brilliant, inspired, and effective work of Vagina Warriors everywhere....

Blending art and activism, V-Day has funded over five thousand community-based antiviolence programs working to end violence against women. Since 1999, over two thousand V-Day benefits have been produced on college campuses. More than nine hundred V-Day benefits have been held in local communities.

1998

V-Day began with a benefit on February 14, 1998, at New York's Hammerstein Ballroom, featuring over twenty actors, including BETTY, Margaret Cho, Glenn Close, Eve Ensler, Giselle Fernandez, Calista Flockhart, Whoopi Goldberg, The Klezmer Women, Shirley Knight, Soraya Mire,

Kathy Najimy, Rosie Perez, Hannah Ensler-Rivel, Robin Roberts, Winona Ryder, Susan Sarandon, Lois Smith, Phoebe Snow, Gloria Steinem, Marisa Tomei, Lily Tomlin, Ulali, Barbara Walters, and Chantal Westerman. The event sold out twenty-five hundred seats. The energy in the room was palpable. The performances were brilliant. The movement was born.

1999

The V-Day movement expanded internationally with V-Day London at England's renowned Old Vic Theatre. The event raised funds for national and international charities that work to end violence against women. Performers included Gillian Anderson, Cate Blanchett, Sophie Dahl, Melanie Griffith, Joely Richardson, Meera Syal, and Kate Winslet. V-Day London received so much media coverage that red boas graced the front pages of six London papers the day after the event, making newsstands in Britain look like a vagina sea. Lawyer Nancy Rose came on board to donate her legal talent pro bono, as she continues to do today. Soon after, Janet Dobrovolny also began offering pro bono legal services to V-Day.

2000

In 2000, V-Day continued to grow at lightning speed and was successful in spreading the mission across wide and diverse networks. That outreach included the pivotal event of a major V-Day LA production of THE VAGINA MONOLOGUES with a cast that included Gillian Anderson, Melissa Etheridge, Calista Flockhart, and Winona Ryder.

2001

On February 10, 2001, V-Day took back the Garden! Over eighteen thousand people sold out V-Day 2001 at New York City's Madison Square Garden, which featured over seventy actors performing THE VAGINA MONOLOGUES. The performers included Mary Alice, Dani Behr, BETTY, Rachel Blanchard, Nell Carter, Kathleen Chalfant, Glenn Close, Claire Danes, Joan Darling, Lolita Davidovich, Viola Davis, Linda Ellerbee, Eve Ensler, Susie Essman, Edie Falco, Calista Flockhart, Jane Fonda, Teri Garr, Gina Gershon, Robin Givens, Sharon Gless, Chloe Goodchild, Hazelle Goodman, Julie Halston, LisaGay Hamilton, Melissa Joan Hart, Teri Hatcher, Amy Irving, Erica Jong, Carol Kane, Julie Kavner, Shirley Knight, Swoosie Kurtz, Ricki Lake, Sanaa Lathan, Queen Latifah, Lisa Leguillo, Jennifer Lewis, Roma Maffia, Ann Magnuson, Julianna Marguiles, Andrea Martin, Marsha Mason, Rue McClanahan, Mary McCormack, Mary McDonnell, Matsha McElhone, Ali McGraw, Mikvah, Soraye Mire, Kathy Najimy, Cynthia Nixon, Joan Osborne, Pratibha Parmar, Rosie Perez, Tonya Pinkins, Katie Puckrik, Gloria Reuben, Shiva Rose, Winona Ryder, Annabella Sciorra, Brooke Shields, Lois Smith, Phoebe Snow, Gloria Steinem, Julia Stiles, Elizabeth Streb, Alicia Svigals, Mary Testa, Marlo Thomas, Marisa Tomei, Lily Tomlin, Ulali, Lynn Whitfield, Kimberly Williams, Rita Wilson, and Oprah Winfrey. In a single evening, $1 million was raised.

V-Day began supporting groups in Afghanistan in 1998, and in December 2001, in response to the crisis in Afghanistan following September 11, V-Day co-sponsored the Afghan Women's Summit for Democracy in Brussels in December 2001. More than fifty Afghan women gathered to define their blueprint for democracy and security in Afghanistan. Their vision did not include weapons. It did not include military buildup. Their vision focused on education, health care, and ways to change social attitudes toward women and girls.

The V-Day Stop Rape Contest invited women from all over the world to submit their ideas for how to systematically stop rape. Coordinators in each region chose finalists whose plans were both groundbreaking and executable. In Germany, Karin Heisecke and Silke Pillinger's win-

ning idea was to use bread bags printed with the facts and statistics about rape, contact details of organizations where affected persons could find help and advice, and a calendar of related activities. Their idea was implemented in Saarbrucken, Germany, where over 340,000 bags were distributed, and has since spread to other cities throughout Germany.

2002

The V-Counsel, V-Day's advisory board of visionary women, was formed to guide and support the movement. Esteemed members are Carole Black, Cathleen Black, Beth Dozoretz, Eileen Fisher, Jane Fonda, Mellody Hobson, Pat Mitchell, Emily Scott Pottruck, and Joan Steinberg.

V-Day launched the Indian Country Project in the summer of 2002 to raise awareness of the rampant rate of abuse of Native American and First Nations women (3.5 times higher than non-Native women, according to the U.S. Department of Justice). Developed by Native American activist Suzanne Blue Star Boy, the project created over twenty-five V-Day events that either took place on reservations and/or benefited Native groups during V-Day's 2003 season.

Twenty-four women's groups came together to stage a star-studded V-Day San Francisco event at the Masonic Auditorium. Among others, the cast included Jill Eikenberry, LisaGay Hamilton, Amel Larrieux, Rita Moreno, Kathy Najimy, Rosie Perez, and California state senator Jackie Speier and raised more than half a million dollars for over twenty-four women's antiviolence groups.

V-Day Spokane 2002 raised over $14,000 for local antiviolence groups, including Stop the Clock. With the money raised, Stop the Clock was able to open an office, create a lending library, attend the state conference on sexual assault, and create a website cataloguing all of the groups in the area coordinating and creating widespread awareness of events in the community.

Activist Agnes Pareyio's vision was fully realized with the April 2002 opening of the first V-Day Safe House for the Girls in Narok, Kenya. With rooms for fifty residents, the safe house provides an alternative ritual for girls, saving them from female genital mutilation and early-childhood marriage, and enables them to continue their schooling. Since opening the house, Agnes has not only saved hundreds of girls from being cut but was recently elected deputy mayor of Narok.

V-Day funds have helped to build safe houses on Pine Ridge Reservation, South Dakota; in Cairo, Egypt; and in Iraq. The shelters in Cairo and Iraq will be the first of their kind.

V-Day Harlem 2002 brought a star-studded cast to New York's world-famous Apollo Theatre. Co-produced by LisaGay Hamilton and Rosie Perez, V-Day Harlem 2002 featured music, dance, and a performance of THE VAGINA MONOLOGUES by a diverse cast of women including Mary Alice, Starla Benford, Bhaswati Bhattacharya, Kim Crenshaw, Rosario Dawson, Eve, Eve Ensler, Takayo Fischer, Free, Cynthia Garrett, Hazelle Goodman, Denyce Graves, LisaGay Hamilton, Salma Hayek, Amy Hill, Sakina and Madhur Jaffrey, LaChanze, Amel Larrieux, Lisa Leguillo, Mariposa, Angie Martinez, S. Epatha Merkerson, Rosie Perez, Tonya Pinkins, Sweet Honey in the Rock, Tamara Tunie, Kerry Washington, and Lynn Whitfield. Proceeds from V-Day Harlem benefited the African-American Task Force on Violence Against Women in Central Harlem; the Dominican Women's Development Center, the Violence Intervention Program; and Sakhi.

2003

Devastated by war, Sarajevo became a metaphor for the possibility of bringing peace and coexistence between different cultures and religions. "Crossing the Borders of Differnce," V-Day Sarajevo 2003 reinforced the message of peace in this turbulent region and brought together activism, art, memories, and a celebration of women's bodies. The performance of THE VAGINA MONOLOGUES in various regional languages strengthened the women's solidarity and support for one another, helping them to understand that there are no borders when we are all working toward one goal.

In February 2003, twenty-nine Vagina Warriors from the UJA (United Jewish Appeal) Federation stepped onto the stage at Town Hall in New York City and performed THE VAGINA MONOLOGUES to a full house. The $240,000 proceeds were donated to Jerusalem Shelter for Battered Women; F.E.G.S. (Federation Employment and Guidance Service, Inc.); Jewish Board of Family and Children's Services; and New Start Loan Fund.

An event in London featured a cast of over thirty-six disabled women (sensory and physical), fourteen sign language interpreters, captioners, audio describers, and twenty access workers.

V-Day invited men to contribute a V-World monologue based on their vision of what the world will look like when violence against women ends. These original monologues were performed by their authors at their local V-Day benefits. Male monologists included the under-sheriff of Ukiah, California, Gary Hudson.

In April 2003, grassroots activist Nighat Rizvi gathered together a cast of leading Pakistani actresses, including Ayeshah Alam, Bilquis Tahira, Nadia Jamil, Samina Peerzada, Zainab Omar Mahmood, and Sameeta, for the first V-Day in Islamabad, Pakistan. Over two hundred people attended the invitation-only event at the Marriott Hotel. Women literally risked their lives both to perform the piece and attend the performance. After the success of the event, the play went on to tour Lahore and Karachi.

V-Day Lithuania 2003 took place on the national radio station as "radio theater"—a seventy-year-old tradition that many rural people rely upon for entertainment.

In Manila, The New Voice Company and Philippine Women legislators and Congressional Representatives staged THE VAGINA MONOLOGUES as a V-Day event for both the Philippine Senate and Congressional House in 2002. The event inspired renewed interest and focus on the bills concerning domestic violence and sex trafficking of Filipina women and children. A year later, after many years of sitting on the Congress and Senate floors, the bills were passed.

The first V-Day Public Service Announcement (PSA) campaign debuted in 2003 featuring V-Day star supporters and activists speaking about "When violence against women and girls ends..." The print PSAs were featured in over forty magazines, including TIME, MARIE CLAIRE, SPIN, and REDBOOK. The televised PSAs—produced pro bono by Lifetime Television—were broadcast more than one hundred times, reaching over ten million viewers.

Chanel Luck, V-Day Skidmore 2003 College Campaign organizer, wrote a resolution calling for the creation of a sexual assault student resources center staffed with a trained victim-advocate counselor on campus. The resolution was unanimously passed with booming applause and a standing ovation from Skidmore's senate. The Presidential Discretionary Fund allocated $20,000, and the Student Government Association gave an additional $10,000 for V-Day and S.A.F.E.R. (Students Active for Ending Rape) members to work with administrators and students on designing a Center for Safer Sexual Relations. The center opened on March 11, 2003.

In July 2003, South Asian Sisters, a collective of progressive South Asian women, presented YONI KI BAAT. Modeled after THE VAGINA MONOLOGUES, YONI KI BAAT, or "Talks About the Vagina," was a collection of original poems, dances, and other performance pieces by nineteen women. Two performances, for one mixed and one all-female audience, took place at UC Berkeley. Pieces discussed abuse, masturbation, orgasm, menstruation, homosexuality, incest, joy, discovery, and pleasure. YONI KI BAAT raised $5,000 to fight domestic violence in Bay Area South Asian communities. The show received a positive response and spurred several more YONI KI BAAT events and performances.

V-Day's 2003 Spotlight on Native American women and Canadian First Nations women in Canada began with a very special honor: a feast and buffalo dance on tribal land of New Mexico's Taos Pueblo Native Community. The lieutenant governor of the Pueblo Tribe welcomed Eve and the V-Day delegation, and a standing-room-only community-room audience enjoyed the feast and the dance.

2004

In April 2004, the first transgender V-Day was staged at Los Angeles' Pacific Design Center. It was a spectacular evening of celebration, performance, and education, illuminating the horrific violence survived by transgender women. The women premiered a new monologue, "They Beat the Girl out of My Boy . . . or They Tried," by Eve, based upon their stories.

For V-Day Nairobi 2004, models, actresses, and politicians joined together for a performance of THE VAGINA MONOLOGUES honoring a local two-year-old girl who was raped and murdered in Nairobi two weeks prior to the event. The evening raised over $4,000 for the Rape Crisis Centre at the Nairobi Women's Hospital and the V-Day Safe House for the Girls in Narok.

On March 8, 2004, THE VAGINA MONOLOGUES was performed in London for V-Day Westminster by women politicians across party lines. Members of Parliament included Joan Ruddock, Caroline Spelman, Sandra Gidley, and Oona King, as well as the Home Office minister Caroline Flint, who performed alongside Jerry Hall, Meera Syal, and Anita Roddick before a sold-out audience at the Criterion Theatre in London. In addition, there were over seventy local V-Day performances in communities across the UK.

V-Day LUNA 2004 (Luna Bar, a V-Day sponsor) united corporate employees and community members in a sold-out benefit performance of THE VAGINA MONOLOGUES raising close to $20,000 and celebrating vaginas in the boardroom.

High school students in Amherst, Massachusetts, with the support of the school superintendent, principal, and faculty members, organized a V-Day in March 2004. The sold-out event was part of a weeklong educational program organized by the school focusing on violence against women. It received national media coverage, including TIME magazine and the TODAY show.

On V-Day, February 14, 2004, more than seven thousand people joined the V-Day and Amnesty International March on Juárez, Mexico. The protesters, including thousands who crossed the bridge from neighboring El Paso, Texas, were standing up for the hundreds of missing and murdered women of Juárez, their families, and the grassroots groups working to end violence in Juárez.

UNTIL THE VIOLENCE STOPS, the first documentary about V-Day, world-premiered at the 2004 Sundance Film Festival and broadcast-premiered on Lifetime Television in February 2004. Directed by Abby Epstein, the film was shot on location in nine countries and features appearances by Tantoo Cardinal, Rosario Dawson, Eve Ensler, Jane Fonda, LisaGay Hamilton, Salma Hayek, Rosie Perez, and Isabella Rossellini.

Since the V-Day College Campaign was founded in 1999, V-Day benefits have taken place each year at Georgetown University, a Catholic university. Funds raised have benefited many local groups, and plans for V-Day Georgetown 2005 are in the works.

V-Day organizers around the world communicate via V-Day's website and the organizer-only forum, known as the V-Spot. In 2004, V-Day's Boston-based web design firm Studio Module won the Horizon Interactive Award in the Public Service category for the V-Day website.

V-Day India 2004 celebrated the work of South Asian feminists. Highlights included two sold-out V-Day India gala performances of THE VAGINA MONOLOGUES featuring Indian and Pakistani actresses, including Avantika Akerkar, Jayati Bhatia, Sonali Mahimtura, Mahabanoo Mody-Kotwal, Dolly Thakore, Ayeshah Alam, and Nighat Rizvi, with Jane Fonda, Marisa Tomei, and Eve Ensler; a trip to Jagori's developing learning center in Himachal Pradesh; and a conference of South Asian activists from India, Pakistan, Bangladesh, Nepal, Afghanistan, and Sri Lanka. The issues and the events were covered broadly by the Indian and international news media, including stories in THE TIMES OF INDIA, on BBC, and by the Associated Press, generating massive awareness on the Indian subcontinent and beyond. V-Day is supporting the opening of a sanctuary for women in Himachal.

With the support of the European Commission, V-Day organizers in the UK, France, Germany, and Luxembourg have joined forces in establishing V-Day Europe. Together they will work to support local organizers, mobilize political and public support in the participating countries and on the broader European level, and develop a sustainable and expansive multidisciplinary network in Europe devoted to ending violence against women and girls.

Sign language was center stage at V-Day Portland, starring a cast of fourteen actresses who performed in American Sign Language. Numerous V-Days have featured deaf casts, but this was the first one to take place in Maine.

V-Day Tulsa, an Indian Country Project event featuring a solo performance of THE VAGINA MONOLOGUES by Eve, raised $1,859 for the 2004 Spotlight on Juárez and $16,734 for Spirits of Hope, a local antiviolence coalition providing services to Native American women in Oklahoma. This donation compensated for the Spirits of Hope's loss of federal funding, allowing the coalition to remain open and continue providing services in the community.

In June 2004, V-Day launched its first voting campaign to get out the vote and elevate the issue of violence against women within the elec-

tion cycle. V-Day activists registered to get out the vote in over thirty states. Ultimately, V-Day will mobilize its activism into political power through V Is For Vote as V-Day supporters "Vote to End Violence."

Corporate support has grown with the movement. V-Day salutes its longtime supporters Barneys New York, Bobbi Brown, EILEEN FISHER, Fairmont Hotels & Resorts, Hearst, Lifetime Television, Liz Claiborne, Luna Bar, Marie Claire, Tampax, Time Inc., and Vosges Haut Chocolates.

OUTRAGEOUS VAGINA MOMENTS

• A 1997 CNN ten-minute special on THE VAGINA MONOLOGUES that never mentions the word. Two years later, a CNN/TIME magazine segment on Eve as "America's Best Feminist" uses the word "vagina" repeatedly.

• At V-Day's 2002 summit in Sophia, Bulgaria, uniting women from the Balkans, women introducing themselves by saying "vagina" in their native languages.

• A seventy-year-old man in a trance walking into Eve's dressing room unannounced after a show to tell her that he "finally got it." Two months later he brings his girlfriend back with him and she thanks Eve.

• V-Day 2004 organizers baking vagina cookies for their event in Cairo, Egypt.

• Vagina quilts hanging in stores downtown in Ukiah, CA—community members coming by at night with flashlights to see the quilts.

• A huge billboard of THE VAGINA MONOLOGUES at the Indira Gandhi International Airport in Delhi, India.

• Hundreds of women wearing red and pink scarves standing together in formation and creating a living vagina monument on the National Mall in Washington, DC.

• Radical cheerleaders greeting Eve by cheering about masturbation and loving their vaginas on February 14, 2003, in the quad of the University of Michigan, Ann Arbor.

• Hundreds of international women trade unionists screaming "cunt" in Melbourne, Australia.

• Eve attending a local community production of V-Day on the island

of Kauai, Hawaii, where the Grammy-nominated singer Toni Childs sang the monologue "My Vagina Was My Village."

• V-Day's 2003 leadership summit in Kabul attended by over 75 Afghan women from throughout the country.

• Organizers in Durango, CO, marching in their local Snowdown Parade and handing out Tampax with invitations to their V-Day event.

• V-Day 2004 benefit banned by government officials in Shanghai, China, and Chennai, India.

• V-Day organizers in Johannesburg, South Africa, standing at highly visible traffic intersections with signs saying "Honk if you love vaginas."

• THE VAGINA MONOLOGUES' first Braille script in 2003 to honor a Vagina Warrior in Akron, OH.

• A vagina sing-along auction in Lübeck, Germany.

• Nine cities, including San Francisco, CA; Akron, OH; Harrisburg, PA; Timmins, Ontario, Canada; Taos, NM; Westminster, MD; Scranton, PA; Newport, RI; and Manila, Philippines, declared Rape-Free Zones by their mayors.

• A preschool-aged girl disabling a potential rapist and making national news as the youngest girl in Kenya to stop rape using self-defense techniques taught at a V-Day-sponsored program.

• Women in the audience during Pakistan's first-ever V-Day event, laughing so hard their scarves fell off, draping down their backs.

• Chanting "Yoni" (VAGINA in Hindi) with activists from India and around the world while lighting 1,000 candles in a Buddhist ceremony at the Norblinka nunnery in Himachal Pradesh, India.